Basic
IDENTITY

BASIC IDENTITY
Copyright 2010
INDEX BOOK, SL
Consell de Cent, 160 local 3
08015 Barcelona
T +34 93 454 5547
F +34 93 454 8438
ib@indexbook.com
www.indexbook.com

Publisher: Sylvie Estrada
Design: Andrea Espadinha
Cover Design: Ivana Kábelová
ISBN: 978-84-92643-58-5

The captions and artwork in this book are based on material supplied by the designers whose work is included. No part of this publication may be reproduced or transmitted in any form or by any means, electronic or mechanical, including photocopy, recording or any information storage and retrieval system, without permission in writing from the copyright owner(s). While every effort has been made to ensure accuracy, Index Book under any circumstances accept responsibility for any errors or omissions.

Printing: Dami Editorial & Printing Services Co.Ltd.

GEORGIAN COLLEGE LIBRARY

Basic
IDENTITY

Library Commons
Georgian College
One Georgian Drive
Barrie, ON
4M 3X9

Pages

006 - 067

068 - 207

208 - 253

254 - 313

314 - 345

346 - 356

Art and Culture
Business Services
Shops
Lifestyle
Manufacturing
Final Directory

Art and Culture
006 - 067

NOW

MEETINGS IN THE PRESENT CONTINUOUS

001/
Sonsoles Llorens

Art and Culture

Festival Eñe

002/
Erretres Diseño

Art and Culture

010
/
011

003/
Adrián Pérez

Art and Culture

012
/
013

004/
Sonsoles Llorens

005/
Paprika

Art and Culture

014
/
015

006/
Poskeone

007/
take off - media services

Art and Culture

016
/
017

008/
Gradesbcn

Mijn
Auteursrecht

009/
Karen van de Kraats

Art and Culture

018 / 019

010/
Erretres Diseño

Art and Culture

7
SEVENX
SEVEN

011/
Landor Associates

Art and Culture

022
/
023

012/
shailesh khandeparkar

Art and Culture

024
/
025

shailesh khandeparkar
illustrator/designer

+ 9 8 2 0 9 6 1 9 1 5

013/
perez-colomer

Art and Culture

026 / 027

:D

014/
Trapped in Suburbia

Art and Culture

028
/
029

015/
Entre Líneas / Mediopunto

Art and Culture

016/
Apfel Zet

Art and Culture

032
/
033

M + DISCOVER = DISCOVER

M + EXCITEMENT = EXCITEMENT

MELBOURNE SUSTAINABLE BUILDING 2009

TASTE

DAZZLE

017/
Landor Associates

Total Watermark
City as a catchment

Working together for Melbourne

Cultural Diversity

Summer in the City
Event Guide

CITY OF MELBOURNE

Art and Culture

034
/
035

018/
Dot

Art and Culture

036
/
037

019/
Gramma

020/
En Publique

Art and Culture

038
/
039

021/
Dot

Art and Culture

040
/
041

022/
Alambre Estudio

THE LAND OF

Art and Culture

023/
Kimberly Ellen Hall

024/
Ten26 Design Group, Inc.

Art and Culture

044
/
045

025/
Clim & Drusk

026/
beygrafic
Beatriz Rodríguez

Art and Culture

046
/
047

027/
Landor Associates

A positive attitude is the key to a happy life, for the planet and for us.

One Degree is all about you. There are tips and tools to reduce your own carbon footprint and incentives to make tackling climate change a priority every day. We will report on what we're doing, what impact we're having and how we can achieve more. One Degree of change.

Ask the people around you or check out the website.
1degree.net.au

One Degree
of attitude

A News Limited Initiative 1degree.net.au

Art and Culture

048
/
049

028/
Christian Leifelt Studio

No Place To Hide*

* this area is under surveillance

SNYK Skive Ny Kunstmuseum

Art and Culture

050 / 051

No Place To Hide No Place To Hide
08.02-13.04 2009 08.02-13.04 2009
Tir-Søn kl. 12-16 Tue-Sun 12-04pm

SNYK Skive Ny Kunstmuseum / Havnevej 14
DK-7800 Skive. www.skivekunstmuseum.dk

029/
Christian Leifelt Studio / shiftcontrol

030/
BENBENWORLD

031/
Entre Líneas

Art and Culture

054
/
055

032/
Atelier Bubentraum

> Pirkanmaan ammattikorkeakoulu ja Tampereen ammattikorkeakoulu yhdistyvät 1.1.2010. Syksyn yhteishaussa opiskelupaikan saaneet aloittavat opiskelun yhdistyneessä Tampereeen ammattikorkeakulussa, TAMKissa. Uusi TAMK on monialainen hyvinvointiin, tekniikkaan ja talouteen keskittyvä vetovoimainen korkeakoulu Pirkanmaalla. TAMK toimii Tampereen lisäksi Ikaalisissa, Mänttä-Vilppulassa ja Virroilla. Opiskelijoita yhdistyneessä ammattikorkeakoulussa tulee olemaan lähes 9000.

Tampereella tammikuussa 2010 alkavaa koulutusta

NUORTEN YHTEISHAUSSA
> Kätilö (AMK)
> Sairaanhoitaja (AMK)
> Terveydenhoitaja (AMK)

Haku internetissä ammattikorkeakoulujen nuorten yhteishaussa 14.–25.9. www.amkhaku.fi Hakupalvelu on auki vain hakuaikana.

AIKUISKOULUTUKSEN YHTEISHAUSSA
> Sairaanhoitaja (AMK) – pohjakoulutusvaatimuksena on sosiaali- ja terveysalan perustutkinto tai vastaava aikaisempi tutkinto tai vastaava ulkomailla suoritettu tutkinto
> Tradenomi, oikeudellisen asiantuntijuuden suuntautumisvaihtoehto

Haku internetissä ammattikorkeakoulujen aikuiskoulutuksen yhteishaussa 28.9.–9.10. www.amkhaku.fi Hakupalvelu on auki vain hakuaikana.

Lisätietoja www.piramk.fi ja www.tamkhaku.fi tai hakutoimisto p. (03) 245 2395, 245 2397 hakutoimisto@tamk.fi.

TAMK TAMPEREEN AMMATTIKORKEAKOULU
Kuntokatu 3 I 33520 Tampere | p. xxx xxxxx

TAMK
TAMPEREEN
AMMATTIKORKEAKOULU
UNIVERSITY OF
APPLIED SCIENCES

Art and Culture

033/
Hahmo Design Oy

034/
Gobranding

Art and Culture

058 / 059

035/
Visual Material

Art and Culture

060
/
061

036/
Visual Language LLC Ellen Shapiro

RED
DE CENTROS
DE INTERPRETACIÓN
ETNOGRAFICA
DE ANDALUCÍA

BASE

037/
Dot

Art and Culture

062
/
063

001/ - Identity number
Sonsoles Llorens - Studio name
CCCB - Client name
Spain - Country

001/
Sonsoles Llorens
CCCB Centro de Cultura
Contemporánea de Barcelona
Spain

002/
Erretres Diseño
La Fábrica
Spain

003/
Adrián Pérez
BICITI
Spain

004/
Sonsoles Llorens
Tatiana Kourochkina. Galeria de arte
Spain

005/
Paprika
Arte Musica Foundation
Canada

006/
Poskeone
Henry ChalFant & Colectivo Graffitiarte
México

007/
take off - media services
kmt - Kasseler Musiktage e. V
Germany

008/
Gradesbcn
SALSANIMA
Spain

009/
Karen van de Kraats
BNO
Netherlands

010/
Erretres Diseño
Comunidad de Madrid
Spain

011/
Landor Associates
Design Institute of Australia
Australia

012/
shailesh khandeparkar
shailesh khandeparkar
India

013/
perez-colomer dgc/sl
Generalitat Valenciana
Spain

014/
Trapped in Suburbia
Diligentia Theater
Netherlands

015
Entre Líneas / Mediopunto
Gobierno de la Rioja
Spain

016/
Apfel Zet
Illustrative Berlin
Germany

017/
Landor Associates
City of Melbourne
Australia

018/
Dot
Andalucía Emprende, Fundación Pública
Andaluza
Spain

019/
Gramma
Zoersel
Belgium

020/
En Publique
Culturehouse Stefanus
Netherlands

021/
Dot
Andalucía Emprende, Fundación Pública
Andaluza
Spain

022/
Alambre Estudio
Sagardoetxea
Spain

023/
Kimberly Ellen Hall
The Land Of
United States

024/
Ten26 Design Group, Inc.
Ela Area Public Library
United States

025/
Clim & Drusk
Week &
Spain

026/
beygrafic
Beatriz Rodríguez
Ona festivals
Spain

027/
Landor Associates
News Limited
Australia

028/
Christian Leifelt Studio
SNYK - Skive Ny Kunstmuseum
Denmark

029/
Christian Leifelt Studio / shiftcontrol
Unity Technologies
Denmark

030/
BENBENWORLD
ESA Saint-Luc
Belgium

031/
Entre Líneas
Colegio Público Dr. Castroviejo
Spain

032/
Atelier Bubentraum
Swisspipers
Switzerland

033/
Hahmo Design Oy
Tampereen ammattikorkeakoulu TAMK /
Tampere University of Applied Sciences
TAMK
Finland

Art and Culture

064
/
065

034/
Gobranding
The City of Katowice
Poland

035/
Visual Material
Mercy Man Productions
United Kingdom

036/
Visual Language LLC
Ellen Shapiro
The Garden Club of Irvington-on-Hudson
United States

037/
Dot
Red de Centros de Interpretación
Etnográfica de Andalucía
Spain

Business Services
068 - 207

038/
Karen van de Kraats

Business Services

070
/
071

039/
Blok Design

Business Services

072
/
073

040/
MusaWorkLab

Business Services

074 / 075

kika ioannidou

041/
TWOFOURTWO

Business Services

076 / 077

042/
Gorka Aizpurua

043/
WeEatDesign

Business Services

078
/
079

044/
gira

045/
PokPok Industrias

Business Services

080 /
081

046/
Jeff Fisher LogoMotives

047/
Clim

082 / 083

Business Services

048/
me studio

084
/
085

Business Services

049/
me studio

050/
Studio Diego Feijóo

Business Services

051/
Dúctil

052/
Landor Associates

Business Services

088 / 089

053/
Pride Studio Sdn Bhd

Business Services

090
/
091

054/
Estudi Duró

JOHN HYAM // PHOTOGRAPHER

JOHN HYAM // PHOTOGRAPHER

055/
MusaWorkLab

Business Services

092
/
093

056/
El Paso, Galería de Comunicación / Álvaro Pérez

Business Services

057/
m Barcelona

bautec Marks + Springer

058/
b mal x, Kommunikation

Business Services

096 / 097

euphoria

marketing & comunicación

059/
Chiara Giacomini | brand design

Business Services

098 / 099

060/
MusaWorkLab

Business Services

100 / 101

KOOMEDIA
NETWORK

KOOMEDIA
NETWORK

061/
PANZER.Strategic Design

Business Services

062/
COEN! bureau voor vormgeving

063/
El Paso, Galería de Comunicación / Álvaro Pérez

Business Services

104 / 105

064/
Studio Sancisi

Business Services

106 / 107

065/
Studio Sancisi

066/
Transporter Visuelle Logistik

Business Services

108
/
109

this is our **proposal**™

this is my **card**™

this is just to **say:**

this is our **cd**™

this is our **letterhead**™

this is our **envelope**™

067/
MINE™

Business Services

110 / 111

068/
El Paso, Galería de Comunicación / Álvaro Pérez

Business Services

112
/
113

069/
me studio

Business Services

114
/
115

MIGUELORTSVIZCARRA
PHOTOGRAPHY

070/
LOOM creativos

Business Services

116
/
117

071/
Kawakong Designworks

072/
MusaWorkLab

Business Services

073/
Virgen extra

Business Services

074/
Paprika

075/
Guillermo Brotons + Walter Hutton

076/
busybuilding

clínica
pedro bujanda

Business Services

124
/
125

077/
Entre Líneas

078/
Zoo Studio SL

Business Services

126
/
127

079/
reaktiff artworks

Business Services

128
/
129

080/
Julia Brunet

081/
In Africa

082/
Paprika

083/
Virgen extra

Business Services

132 / 133

084/
busybuilding

Business Services

085/
MusaWorkLab

Business Services

136 / 137

086/
m Barcelona

Business Services

138 / 139

087/
Barfutura

088/
BENBENWORLD

Business Services

089/
Scale to Fit

Serving the nation. Trust us. Time to shine. Watch out. Pay me. This side up. We like you.

Business Services

142 / 143

090/
804 GRAPHIC DESIGN

Business Services

144 / 145

091/
Prompt Design

092/
Korolivski mitci

Business Services

146 / 147

093/
Korolivski mitci

Business Services

148
/
149

094/
Ivan Nook

095/
Diseño Dos Asociados

Business Services

150
/
151

096/
Ten26 Design Group, Inc.

097/
Diseño Dos Asociados

Business Services

098/
Guillermo Brotons

LA–
PESCH

Business Services

154 / 155

100/
Kawakong Designworks

Business Services

156
/
157

101/
connie hwang design

102/
Trapped in Suburbia

Business Services

158 / 159

103/
PLAN B WORKS

studio BANANA .TV

Business Services

160 / 161

104/
PLAN B WORKS

TAMARA URIBE
PHOTOGRAPHY

Business Services

162 / 163

Ambachtshuis

107/
Studio Sancisi

Business Services

166 / 167

DIPL.-ING.
JÖRG SCHNEIDER

DIPL.-ING.
ROLAND SCHWEIGER

ARCH. DIPL.-ING.
FLORIAN LAMPRECHT

DIPL.-ING.
MICHAEL SMOLY

108/
Transporter Visuelle Logistik

Business Services

168 / 169

codigoarquitectura
+ design

109/
AxiomaCero

Business Services

170 / 171

110/
projectGRAPHICS

Business Services

172 / 173

cybex

The Digital Forensic Company

111/
la regadera grafica (Albert Terré)

Business Services

174 / 175

112/
Hollis Duncan

Business Services

176 / 177

113/
Logoorange Design Studio

114/
Jose Palma Visual Works

116/
804 GRAPHIC DESIGN

Business Services

180 / 181

117/
Xosé Teiga

118/
UVE Diseño y Comunicación, S.L.

mentours
english
teaching
& services

english metas

Business Services

184
/
185

119/
Mediopunto

Business Services

186 / 187

120/
m Barcelona

121/
Summerdesign

Business Services

188
/
189

123/
Karen van de Kraats

Business Services

124/
Ping Pong Studio

125/
projectGRAPHICS

Business Services

192 / 193

126/
Bob Delevante | STUDIO

127/
take off - media services

Business Services

128/
Nómada

129/
Logoorange Design Studio

BLUHM | PARTNER

Dipl-Ing (Univ)
Ján Bluhm

Helene-Mayer-Ring 14/2
80809 Munich, Germany

Tel +49 89 1228227932
Fax +49 89 1228227931
Mobil +49 151 12452402
Mail j.bluhm@bluhmpartner.com
Web www.bluhmpartner.com

130/
SOPA

132/
Bruno Baeza

Business Services

200
/
201

133/
Transporter Visuelle Logistik

Business Services

202 / 203

001/ - Identity number
Sonsoles Llorens - Studio name
CCCB - Client name
Spain - Country

038/
Karen van de Kraats
Cream PR
Netherlands

039/
Blok Design
Taller de Empresa
México

040/
MusaWorkLab
Som de Lisboa
Portugal

041/
TWOFOURTWO
Kika Ioannidou
Cyprus

042/
Gorka Aizpurua
A small job (Juan Pablo Sanchez)
Spain

043/
WeEatDesign
One
México

044/
gira
gira
Spain

045/
PokPok Industrias
DGA Abogados
Spain

046/
Jeff Fisher LogoMotives
Emerge Medical Spa at Bridgeport Village
United States

047/
Clim
Cucumm, passió audiovisual
Spain

048/
me studio
We Jane
Netherlands

049/
me studio
Suikerdepot
Netherlands

050/
Studio Diego Feijóo
Creas Foundation
Spain

051/
Dúctil
Margarida Llabrés
Spain

052/
Landor Associates
Worldeka
Australia

053/
Pride Studio Sdn Bhd
self promotion
Malaysia

054/
Estudi Duró
Maik Maier
Spain

055/
MusaWorkLab
John Hyam
Portugal

056/
El Paso, Galería de Comunicación / Álvaro Pérez
io community
Spain

057/
m Barcelona
OCU
Spain

058/
b mal x, Kommunikation
bautec, Marx & Springer
Germany

059/
Chiara Giacomini | brand design
Euphoria marketing & comunicación
Spain

060/
MusaWorkLab
Ate
Portugal

061/
PANZER Strategic Design
Koomedia Network
Germany

062/
COEN! bureau voor vormgeving
Oogziekenhuis Eindhoven
Netherlands

063/
El Paso, Galería de Comunicación / Álvaro Pérez
TORCH Spain
Spain

064/
Studio Sancisi
IN.D.A.CO.
Italy

065/ 204
Studio Sancisi /
THW Germany. 205
Italy

066/
Transporter Visuelle Logistik
Dr. Achleitner Steuerberatungsges. m.b.H
Austria

067/
MINE™
MINE™
United States

068/
El Paso, Galería de Comunicación / Álvaro Pérez
El Paso, Galería de Comunicación
Spain

069/
me studio
Monodot
Netherlands

Business Services

070/
LOOM creativos
Miguel Orts Vizcarra / Photographer
Spain

071/
Kawakong Designworks
Building Bloc Architects
Malaysia

072/
MusaWorkLab
IWC
Portugal

073/
Virgen extra
Muu Films
Spain

074/
Paprika
Cloutier, Conceptrice Rédactrice
Canada

075/
Guillermo Brotons + Walter Hutton
Hendzel+Hunt
Spain

076/
busybuilding
Dimitris Poupalos: photographer
Greece

077/
Entre Líneas
Clínica Pedro Bujanda
Spain

078/
Zoo Studio SL
Famgoca
Spain

079/
reaktiff artworks
reaktiffartworks
Spain

080/
Julia Brunet
Salu Juan
Spain

081/
In Africa
In Africa
Australia

082/
Paprika
SAM Communication
Canada

083/
Virgen extra
Oink
Spain

084/
busybuilding
WE SAW: Open Lab.
Greece

085/
MusaWorkLab
Clap/-Box
Portugal

086/
m Barcelona
Pok
Spain

087/
Barfutura
Tornasol Films
Spain

088/
BENBENWORLD
my own identity
Belgium

089/
Scale to Fit
Scale to Fit
Netherlands

090/
804 GRAPHIC DESIGN
Bayer 04 Leverkusen Fussball GmbH
Germany

091/
Prompt Design
ACSF - Asian Clay Shooting Federation
Thailand

092/
Korolivski mitci
Korolivski mitci
Ukraine

093/
Korolivski mitci
Leon Service Plus
Ukraine

094/
Ivan Nook
Epic photography
Spain

095/
Diseño Dos Asociados
Kratos
Mexico

096/
Ten26 Design Group, Inc.
Loren Reid Seaman & Associates Interior Designers
United States

097/
Diseño Dos Asociados
Glass Contract
Mexico

098/
Guillermo Brotons
InfoRad
Spain

099/
LA-PESCH
LA–PESCH
Germany

100/
Kawakong Designworks
MCFC, Mr.Clean Fabricare Centre
Malaysia

101/
connie hwang design
yousendit, inc.
United States

102/
Trapped in Suburbia
Pure Mac
Netherlands

103/
PLAN B WORKS
Studio Banana
Spain

104/
PLAN B WORKS
Human Beauty
Spain

105/
WeEatDesign
Tamara Uribe
Mexico

106/
En Publique
Ambachtshuis Project Development
Netherlands

107/
Studio Sancisi
Verba Manent Cooperative.
Consultorium for people with social problems
Italy

108/
Transporter Visuelle Logistik
beaufort architekten
Austria

109/
AxiomaCero
Codigo Arquitectura
Mexico

110/
projectGRAPHICS
projectGRAPHICS
Kosovo

111/
la regadera grafica
Albert Terré
Cybex
Spain

112/
Hollis Duncan
Clínica Laura Míguez
Spain

113/
Logoorange Design Studio
Jill Howard
Romania

114/
Jose Palma Visual Works
Zoom _ Market & Social Research
Spain

115/
MINE™
NRG Marketing, LLC
United States

116/
804 GRAPHIC DESIGN
Sportschule Hennef
Germany

117/
Xosé Teiga
The Black Shooter
Spain

118/
UVE Diseño y Comunicación, S.L.
English Metas
Spain

119/
Mediopunto
BSA Proyecta
Spain

120/
m Barcelona
Jorge Virgós
Spain

121/
Summerdesign
Caleidoscopio
Netherlands

122/
WeEatDesign
De par en par
Mexico

123/
Karen van de Kraats
Fellows
Netherlands

124/
Ping Pong Studio
Ping Pong Studio
Spain

125/
projectGRAPHICS
maden creative studio
Kosovo

126/
Bob Delevante | STUDIO
Concept Technology Inc.
United States

127/
take off - media services
Lawyer Harald Welge
Germany

128/
Nómada
Xavier Treviño
Mexico

129/
Logoorange Design Studio
Bluhm&Partner
Romania

130/
SOPA
Copisteria Solé
Spain

131/
ATIPUS
New Project Esthetic
Spain

132/
Bruno Baeza
Lady Dilema
Spain

133/
Transporter Visuelle Logistik
Transporter Visuelle Logistik
Austria

Business Services

206 / 207

Shops
208 - 253

!

polka

134/
Dúo Comunicación

Shops

210 / 211

135/
Salvartes Diseño
y Estrategias de Comunicación

Shops

212 / 213

136/
Guillermo Brotons

Shops

137/
Julia Brunet

Shops

216 / 217

138/
&Larry

XTRA

Shops

218 / 219

139/
&Larry

Shops

220
/
221

140/
MINE™

141/
Sublima Comunicación

Shops

222 / 223

142/
Mary Hutchison Design LLC

Shops

224 / 225

143/
Julia Brunet

144/
Carefully Considered

Shops

226 / 227

145/
MusaWorkLab

Shops

228 / 229

146/
House of Graphics LLC

147/
MusaWorkLab

Shops

230 / 231

148/
m Barcelona

Shops

232 / 233

149/
The Creative Method

Shops

234
/
235

150/
Gabe Ruane

Shops

236 / 237

151/
Óscar Germade &
Alba Rodríguez

Shops

238 / 239

152/
Natoof

Shops

240
/
241

153/
Salva García-Ripoll / Mónica Padilla

154/
Kanella

Ε. Αριφάκη

zueco ⓩ

pl. de les olles 4, 08003 bcn
tel. 93 268 17 91

155/
m Barcelona

nahike

157/
di7

SONCATIU
tafona tenda
& degustacions

158/
Marco González

159/
Virgen extra

glamour without guilt!

so many shoes, so little time...

Save energy wash at 30°

great value for all

if love is blind, why is lingerie so popular?

goodbye ...and thanks for shopping with us!

Hey gorgeous!

gotta have it...

All change!

160/
Checkland Kindleysides

Shops

250 / 251

001/ - Identity number
Sonsoles Llorens - Studio name
CCCB - Client name
Spain - Country

134/
Dúo Comunicación
Zapatería Polka!
Spain

135/
Salvartes Diseño y Estrategias de Comunicación
Soder Clothing
Spain

136/
Guillermo Brotons
Il tinello
Spain

137/
Julia Brunet
Lifra
Spain

138/
&Larry
XTRA
Singapore

139/
&Larry
Eye Place
Singapore

140/
MINE™
C Plus Jewelry
United States

141/
Sublima Comunicación
La Industrial
Spain

142/
Mary Hutchison Design LLC
Smart Chocolate LLC
United States

143/
Julia Brunet
IMC
Spain

144/
Carefully Considered
Good Day Skincare
United States

145/
MusaWorkLab
O Epicurista / Loja do Banho
Portugal

146/
House of Graphics LLC
Bangz Salon & Wellness Spa
United States

147/
MusaWorkLab
Moda Lisboa
Portugal

148/
m Barcelona
Happy Pills
Spain

149/
The Creative Method
Guzman Y Gomez
Australia

150/
Gabe Ruane
Viva Yogurt Café
United States

151/
Óscar Germade & Alba Rodríguez
Zerclo
Spain

152/
Natoof
Haifa Kayed - Zilar
United Arab Emirates

153/
Salva García-Ripoll / Mónica Padilla
Remember Collections
Spain

154/
Kanella
E. Arifaki
Greece

155/
m Barcelona
Zueco
Spain

156/
TOOLKOM
Nahike
Spain

157/
di7
Son Catiu
Spain

158/
Marco González
BonBon (Berlotex SL)
Spain

159/
Virgen extra
Mercedes Urquijo
Spain

160/
Checkland Kindleysides
George @ ASDA
United Kingdom

Shops

252 / 253

Lifestyle
254 - 313

161/
Dúo Comunicación

NADA ES COMPARABLE A CENAR EN EL HOLANDES

Lifestyle

256 / 257

162/
Salvartes Diseño y Estrategias de Comunicación

163/
Neil Cutler Design

Lifestyle

Lifestyle

260 / 261

Emmaboshi studio

il Posto
CUCINA ED EVENTUALI

BOLOGNA via Massarenti 37 | **TEL.** 051 307 852
info@ilposto.bo.it | www.ilposto.bo.it

166/
Pupila Estudio

Lifestyle

264 / 265

167/
Neil Cutler Design

168/
ODM Oficina de Diseño y Marqueting

La Bodegueta Provença

zenses
CristalBar

Zenses
PISSARRO DINING

170/
On Your Mark Design Laboratory

Lifestyle

268
/
269

171/
superfried

Lifestyle

270
/
271

GLORY HOLE

non**ell** non**ella**

eazie

salads | wok | smoothies

173/
Doe de Do

Lifestyle

274 / 275

lanevateria.

174/
Bisgràfic

⦵⦵⦵ FËNHOTELES

Lifestyle

276 / 277

175/
Tholön Kunst

176/
3deluxe

Lifestyle

278 / 279

HOMES

SUCOA

TAPAS & PLATILLOS

Neil Cutler Design

CARTA

VINOS

DONES

Lifestyle

178/
Signum Comunicación y Diseño, S.L.

Lifestyle

282 / 283

179/
Mujica TMP

Lifestyle

Gari Artola

Lifestyle

bistro 18

café /
vins /
gourmandises /

181/
Emmaboshi studio for D-sign

Lifestyle

288 / 289

182/
Estudio David Cercós

Lifestyle

THE HIGH TABLE
Brasserie & Bar

Lifestyle

292
/
293

185/
La Cáscara Amarga

Lifestyle

294
/
295

186/
Roberto Núñez

Lifestyle

296 / 297

187/
La Consulta Creativa

188/
Cocolia

I+Drink

189/
m Barcelona

Lifestyle

300 / 301

190/
Sonsoles Llorens

Lifestyle

302
/
303

CENT111ONZE
RESTAURANT

191/
Neil Cutler Design

CENT 111 ONZE
RESTAURANT

Lifestyle

Astrid Ortiz

Lifestyle

306 / 307

193/
Blok Design

Lifestyle

308 / 309

194/
&Larry

THE MARMALADE PANTRY

Lifestyle

310 / 311

001/ - Identity number
Sonsoles Llorens - Studio name
CCCB - Client name
Spain - Country

161/
Dúo Comunicación
Restaurante Doble Q
Spain

162/
Salvartes diseño y Estrategias de Comunicación
Restaurante El Holandés
Spain

163/
Neil Cutler Design
Pansfood S.A
Spain

164/
Davidsilvosa.com
Hosteleria+galicia
Spain

165/
Emmaboshi studio
Il Posto
Italy

166/
Pupila Estudio
Gostoso Organic Juice Bar
Costa Rica

167/
Neil Cutler Design
An Grup
Spain

168/
ODM Oficina de diseño y marqueting
Sopranis
Spain

169/
eggeassociats
La Bodegueta Provença
Spain

170/
On Your Mark Design Laboratory
Zenses Bar & Restaurant
Hong Kong

171/
superfried
GloryHoleMusic
United Kingdom

172/
Neil Cutler Design
Comybe S.A.
Spain

173/
Doe de Do
eazie
Netherlands

174/
Bisgràfic
La Nevateria
Spain

175/
Tholön Kunst
Fën Hoteles
Argentina

176/
3deluxe
Mario Lohninger
Germany

177/
Neil Cutler Design
Grupo Sucoa
Spain

178/
Signum Comunicación y Diseño, S.L.
Sidrería Restaurante Casa Moisés
Spain

179/
Mujica TMP
Bussiness Plus
Ecuador

180/
Gari Artola
Ardoka Vinoteka
Spain

181/
Emmaboshi studio for D-sign
Bistro 18
Italy

182/
Estudio David Cercós
Toledo y Catalá, S.L.
Spain

183/
iDEOlab
Lukas Zerkaosteta
Spain

184/
Blacksheep
Mercure Hotels
United Kingdom

185/
La Cáscara Amarga
Navaho bar
Spain

186/
Roberto Núñez
Licencia para Innovar S.L.
Spain

187/
La Consulta Creativa
Saburdi
Spain

188/
Cocolia
Negre Fum
Spain

189/
m Barcelona
Nacho Cuevas
Spain

190/
Sonsoles Llorens
Klein
Spain

191/
Neil Cutler Design
Starman Hoteles España S.L.
Spain

192/
Astrid Ortiz
Plats
Spain

193/
Blok Design
ödün
Mexico

Lifestyle

312 / 313

Manufacturing
314-345

195/
TOOLKOM

LOFT
CREATION
PROMOCIONES Y CONSTRUCCIONES

Manufacturing

316 / 317

196/
Sublima Comunicación

Manufacturing

318
/
319

197 /
Creative Squall

… instaquim®

Manufacturing

320 / 321

199/
Dúctil

Manufacturing

322
/
323

200/
areaveinte

Manufacturing

324
/
325

201/
Bouzón | Comunicación y Diseño

202/
Grotesk Design S.L.

Manufacturing

326 / 327

Fattoria il Gambero

203/
Ferrariodesign

Manufacturing

328 / 329

204/
Victor Goloubinov

Manufacturing

330 / 331

205/
Primal

Manufacturing

332
/
333

206/
Bisgràfic

neoprén
caucho

207/
Estudiotres

Manufacturing

334
/
335

208/
Pablo Iotti Design

Manufacturing

336 / 337

209/
busybuilding

Manufacturing

AMOND

JAVIER AMONDARAIN
Director Gerente

TALLERES AMONDARAIN

Apartado de correos 7
Bº Akezkoa, s/n
20150 ZIZURKIL (Guipúzcoa) ESPAÑA

t +34 943 69 01 54
f +34 943 69 18 71
m +34 636 47 49 84
e javier@amondarain.com
w www.amondarain.com

AMOND

TALLERES AMONDARAIN
Apartado de correos 7
Bº Akezkoa, s/n
20150 ZIZURKIL (Guipúzcoa) ESPAÑA

t +34 943 69 01 54
t +34 943 69 18 71

w www.amondarain.com

AMOND

210/
eseerre

The Platinum Outdoors Club

Manufacturing

340
/
341

211/
Segura inc - Pablo Iotti Design

212/
A.S.Louken

Manufacturing

342
/
343

213/
Alambre Estudio

001/ - Identity number
Sonsoles Llorens - Studio name
CCCB - Client name
Spain - Country

195/
TOOLKOM
Loft Creation
Spain

196/
Sublima Comunicación
OK TEXTIL
Spain

197/
Creative Squall
Kilowatt Bikes
United States

198/
Bisgràfic
Instaquim
Spain

199/
Dúctil
Mibo cosits
Spain

200/
areaveinte
Odda, tejidos artesanales
Argentina

201/
Bouzón | Comunicación y Diseño
Saint Germain
Argentina

202/
Grotesk Design S.L.
CRICURSA
Spain

203/
Ferrariodesign
Fattoria il gambero
Italy

204/
Victor Goloubinov
Lightstar
Russia

205/
Primal
Plastic Plumbers
México

206/
Bisgràfic
Praia
Spain

207/
Estudiotres
Neoprén Caucho
Spain

208/
Pablo Iotti Design
manifesto
Argentina

209/
busybuilding
Alfa Roufanis
Greece

210/
eseerre
Talleres Amondarain
Spain

211/
Segura inc - Pablo Iotti Design
The Platinum Outdoors Club
Argentina

212/
A.S.Louken
Sonata Dancewear
Singapore

213/
Alambre Estudio
Merak
Spain

Manufacturing

344
/
345

Final Directory
346-356

&Larry - studio name
138/139/194/ - Identity number
www.andlarry.com - Studio website

&Larry
138/139/194/
www.andlarry.com

3deluxe
176/
www.3deluxe.de

804 GRAPHIC DESIGN
090/116/
www.achtnullvier.com

A.S.Louken
212/
www.aslouken.com/

Adrián Pérez
003/
www.adrianperez.com

Alambre Estudio
022/213/
www.alambre.net

Apfel Zet
016/
www.apfelzet.de

areaveinte
200/
www.areaveinte.com

Astrid Ortiz
192/
www.theladyvanishes.es

Atelier Bubentraum
032/
www.bubentraum.com

ATIPUS
131/
www.atipus.com

AxiomaCero
109/
www.axiomacero.com

b mal x, Kommunikation Daniel Henry Bastian
058/
www.bmalx.de

Barfutura
087/
www.barfutura.com

BENBENWORLD
030/088/
www.benbenworld.com

**beygrafic
Beatriz Rodríguez**
026/
www.beygrafic.carbonmade.com

Bisgràfic
174/198/206/
bisgrafic.com

Blacksheep
184/
www.blacksheep.uk.com

Blok Design
039/193/
blokdesign.com

Bob Delevante | STUDIO
126/
bobdelevante.com/

Bouzón | Comunicación y Diseño
201/
www.bouzon.com.ar

Bruno Baeza
132/
brunobaeza.com

busybuilding
076/084/209/
www.busybuilding.com

Checkland Kindleysides
160/
checklandkindleysides.com

Chiara Giacomini | brand design
059/
www.chiaragiacomini.com

Christian Leifelt Studio
028/
www.christianleifelt.com

Christian Leifelt Studio / shiftcontrol
029/
www.christianleifelt.com

Clim
025/ 047/
climentcanal.com

Cocolia
188/
www.cocolia.cat

COEN! bureau voor vormgeving
062/
www.coen.info

connie hwang design
101/
www.conniehwangdesign.com

Creative Squall
197/
www.creativesquall.com

davidsilvosa.com
164/
www.davidsilvosa.com

di7
157/
www.di7.es

Diseño Dos Asociados
095/097
www.disenodos.com

Doe de Do
173/
www.doededo.nl

Dot
018/021/037
www.dot-info.es

Drusk
025/
drusk.net

Dúctil
051/199/
www.ductilct.com

Final Directory

348
/
349

Dúo Comunicación
134/161/
www.duocomunicacion.com

eggeassociats
169/
www.eggeassociats.net

**El Paso, Galería de Comunicación /
Álvaro Pérez**
056/ 063/ 068/
www.elpasocomunicacion.com

Emmaboshi studio
165/
www.emmaboshi.net

Emmaboshi studio for D-sign
181/
www.emmaboshi.net

En Publique
020/106/
www.en-publique.nl

Entre Líneas
031/077/
www.entre-lineas.es

Entre Líneas / Mediopunto
015/
www.entre-lineas.es

Erretres Diseño
002/ 010/
www.erretres.com

eseerre
210/
www.gruposrweb.es

Estudi Duró
054/
www.jordiduro.com

Estudio David Cercós
182/
www.davidcercos.com

Estudiotres
207/
estudiotrescomunicacion.com

Ferrariodesign
203/
www.ferrariodesign.it

Gabe Ruane
150/
www.gaberuane.com

Gari Artola
180/
www.inesfera.com

gira
044/
gira.ws

Gobranding
034/
www.gobranding.eu

Gorka Aizpurua
042/
www.gorkaizpurua.com

gradesbcn
008/
gradesbcn.com

Gramma
019/
www.gramma.be

Grotesk Design S.L.
202/
www.groteskdesign.com

Guillermo Brotons
075/098/136/
www.guillermobrotons.com

Hahmo Design Oy
033/
www.hahmo.fi

Hollis Duncan
112/
www.hollisduncan.com

House of Graphics LLC
146/
www.houseofgrfx.com

iDEOlab
183/
www.ideolab.com

In Africa
081/

Ivan Nook
094/

Jeff Fisher LogoMotives
046/

Jose Palma Visual Works
114/
www.josepalma.com

Julia Brunet
080/137/143/
juliabrunet.com

Kanella
154/
www.kanella.com

Karen van de Kraats
009/038/123/
www.karenvandekraats.com

Kawakong Designworks
071/100/
www.kawakong.com

Kimberly Ellen Hall
023/
nottene.net

Korolivski mitci
092/093/
mitci.com.ua

La Cáscara Amarga
185/
www.lacascaraamarga.com

La Consulta Creativa
187/
laconsultacreativa.com

**la regadera grafica
Albert Terré**
111/
www.laregaderagrafica.com

LA-PESCH
099/
www.la-pesch.com

Landor Associates
011/017/027/052/
landor.com

Logoorange Design Studio
113/129/
www.logoorange.com

LOOM creativos
070/
www.loom-ca.com

m Barcelona
057/086/120/148/155/189/
m-m.es

Marco González
158/
www.marcogonzalez.es

Mary Hutchison Design LLC
142/
www.maryhutchisondesign.com

me studio
048/049/069/
www.mestudio.info

Mediopunto
119/

MINE™
067/115/140/
www.minesf.com

Mujica TMP
179/
www.mujica-tmp.com

MusaWorkLab
040/055/060/072/085/145/147/
www.musaworklab.com/

Natoof
152/
www.natoof.com

Neil Cutler Design
163/167/172/177/191/
www.neilcutler.com

Nómada
128/
www.nomadadesign.com.mx

ODM oficina de diseño y marketing
168/
odmoficina.com

On Your Mark Design Laboratory
170/
onyourmarkdesignlab.com

Óscar Germade & Alba Rodríguez
151/
oscargermade.com

Pablo Iotti Design
208/
www.pabloiotti.com.ar

PANZER Strategic Design
061/
www.panzer.cl

Paprika
005/074/082/
paprika.com

perez-colomer
013/
perez-colomer.com

Ping Pong Studio
124/
www.pingpongstudio.es

PLAN B WORKS
103/104/
www.planbworks.eu

PokPok Industrias
045/
www.aspublicidad.com

Poskeone
006/
poskeone.blogspot.com

Pride Studio Sdn Bhd
053/
pridestudio.com.my

Primal
205/
www.primal.mx

projectGRAPHICS
110/125/
www.projectgraphics.eu

Prompt Design
091/
www.prompt-design.com

Pupila Estudio
166/
www.pupilaestudio.com

reaktiff artworks
079/
www.myspace.com/kikereaktiff

Roberto Núñez
186/
robertonunez.com

Salvartes Diseño y Estrategias de Comunicación
135/153/162/
www.salvartes.com

Scale to Fit
089/
www.scaletofit.com

Segura inc - Pablo Iotti Design
211/
www.pabloiotti.com.ar

shailesh khandeparkar
012/
www.khandeparkarshailesh.blogspot.com

Signum Comunicación y Diseño, S.L.
178/
www.signum.es

Sonsoles Llorens
001/004/190/
www.sonsoles.com

SOPA
130/
www.sopagraphics.com

Studio Diego Feijóo
050/
www.dfeijoo.com

Final Directory

350 / 351

Studio Sancisi
064/065/107/
www.studiosancisi.it

Sublima Comunicación
141/196/
www.sublimacomunica.com

Summerdesign
121/
www.summerdesign.es

superfried
171/
www.superfried.com

take off - media services
007/127/
www.takeoff-ks.de

Ten26 Design Group, Inc.
024/096/
ten26design.com

The Creative Method
149/
www.thecreativemethod.com

Tholön Kunst
175/
tholon.com

TOOLKOM
156/195/
www.toolkom.com

Transporter Visuelle Logistik
066/108/133/
www.transporter.at

Trapped in Suburbia
014/102/
www.trappedinsuburbia.com

TWOFOURTWO
041/
twofourtwo.com

UVE Diseño y Comunicación, S.L.
118/
www.estudiouve.com

Victor Goloubinov
204/
http://revision.ru/a/Golubinov/

Virgen extra
073/ 083/ 159/
virgen-extra.com

**Visual Language LLC
Ellen Shapiro**
036/
www.visualanguage.net

Visual Material
035/

WeEatDesign
043/105/122/
www.weeatdesign.com

Xosé Teiga
117/
www.xoseteiga.com

Zoo Studio SL
078/
www.zoo.ad

Final Directory

352 / 353